WEDDINGS

Vintage People on Photo Postcards

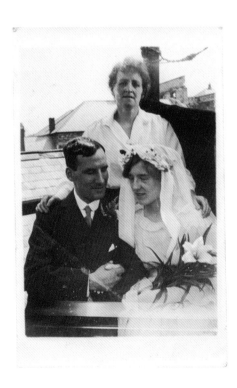

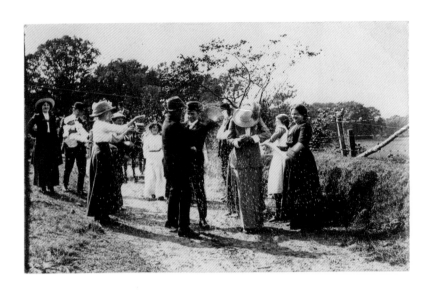

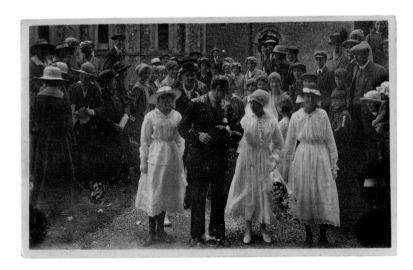

WEDDINGS

Vintage People on Photo Postcards

Tom Phillips

Bodleian Library
UNIVERSITY OF OXFORD

for Fiona
finest of brides

First published in 2011 by the Bodleian Library
Broad Street
Oxford OX1 3BG
www.bodleianbookshop.co.uk

ISBN: 978 1 85124 369 3

Foreword © Giles Waterfield
Text and design © 2011 Tom Phillips
This edition © Bodleian Library, University of Oxford, 2011
All rights reserved

So far published in this series; *Readers*, *Women & Hats*, *Bicycles*, *Weddings*.
Volumes forthcoming; *Men & Fashion*, *Fantasy Transport*.

Designed and typeset in Myriad Pro (10pt on 12pt) by Alice Wood
Printed and bound by Great Wall Printing, China on 157gsm 'Gold East' Matt Art
British Library Cataloguing in Publication Data
A CIP record for this publication is available from the British Library

FOREWORD

Giles Waterfield

The postcards that Tom Phillips has assembled are wonderfully touching. So many smiling faces, so many loving friends and relations, so many lives blossoming – one can only believe – as people begin the process of living happily ever after. For most of the 20th century, the wedding day was the really big day in many people's lives, a once and for all day. For most of the century, after all, divorce was a major issue which could exile people, particularly women (who generally had the roughest deal), from the society of their friends.

My family lived in Geneva in the 1960s, where divorces took place quite often in the expatriate community, and though a divorce tended in those days to mean that the couple would be expected to have nothing more to do with each other – to the distress no doubt of their children – divorce there was nothing unusual. So I was amazed in an idle moment to read a notice in Eton High Street announcing a meeting of the Women's Guild and saying that *even* divorced women would be welcome. It was the fact that you were expected to be tolerant that astonished me. Marrying a

second time round if you were widowed was somehow regarded as dodgy, following a text in Leviticus or somewhere. All this meant that the wedding was pretty much final, the big and absolute decision, the moment when you did indeed commit yourself 'until death us do part'.

Pretty solemn stuff, but still it was more fun than birth or death, the other big ones, and a time to celebrate. Weddings in the long past seem to have been less formulaic than the ones that Tom Phillips chronicles in his evocative selection of postcards, particularly outside Britain: the country wedding banquet described in *Madame Bovary* lasted for days and days. In 19th century England you didn't have to spend so much money on the ceremony, you didn't have to follow certain rules, you could give a 'wedding breakfast' or not as you chose, and it was only the decision by Queen Victoria to marry in white that made white wedding dresses almost a uniform. Somewhere in the late 19th century weddings became ritualised, particularly as a result of the peculiar law which made it impossible (for God's sake, why?) to be married after three in the afternoon. This produced a day of maximum discomfort, wedding at two-thirty, reception at four with champagne and nibbles, headache and general world weariness at six, total collapse at eight. The wedding was

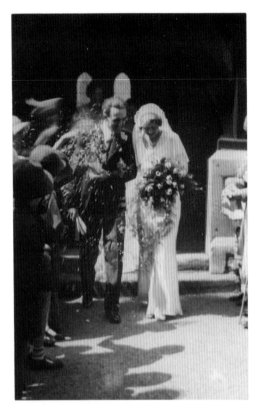

4

events is that these were parties where no one knew more than three other people, and no introductions were made because the bridal couple were wafting around on a cloud of ecstasy and didn't have time to actually talk to anyone. If you were English you just stood around and had more to eat and drink. And then, of course, however cynical you might be, it was hard not to cry now and again.

But that is a jaundiced point of view, no doubt. No one in these photographs looks depressed – except maybe one or two of the men (159). On the contrary, this clearly is the happiest day of their lives for most of the couples and their families. They look so buoyant, so delightful, so good and happy and sure that everything is going to work out. And let's hope that it did, and that they did not die in the war or in childbirth or take to drink or run out of money or beat each other up, or lose interest in each other. I feel pretty confident, looking at all these happy young couples, that it really was all right and that these good sweet innocent people (my, how innocent they all look, by contrast with people today) really had found Mr Right or Mrs Right as they thought they had.

Weddings are better nowadays, of course, at least as social events. No ceremonies in the early afternoon. Lots to eat at a time

accompanied by strange rituals such as tail coats for the men, hats for the women, embarrassing speeches by the godfather about the bride and by the best man about the groom, and later in the proceedings having to eat cake when you already felt slightly sick. My other recollection of these

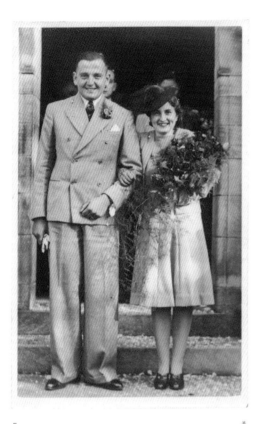

groom takes on a quite different character, when things have to change. The element of gamble is as strong as ever – there is so much that might go wrong. Thank goodness that so often it works out: as the happy faces in these postcards are entirely confident it will.

5 *

when you feel hungry. Dancing late into the night. There's not quite the threat that if you haven't got it right this time, you are taking on a life sentence. But they are still heart-wrenching events, a rite of passage, a moment when for the ones who aren't being married any friendship with bride or

INTRODUCTION

Tom Phillips

Wedding bells must have been sweet music to a local photographer's ears. For him they signalled a bread and butter outing with many possibilities of sales, duplicates to be printed off and padded albums to be made up. Of all the rites of passage between birth and death a traditional wedding is the most provident of photo opportunities, from the arrival of the bride on her father's arm, via the confetti explosion (if allowed, see 34) at the couple's exit, to the reception and the cutting of the cake; not to speak of various groupings of bridesmaids, relatives etc.

In the first half of the 20th century, the period covered by these postcards, the presence of a photographer was almost mandatory, even after the advent of cheap cameras such as the box brownie and faster film let the amateur loose on the scene. An official occasion called for an official record, and a proper photograph to send to family and friends.

No wonder then that there survives such a proliferation of cards relating to every aspect of the event (except that is for its key transformative moment since photography was taboo inside the church or even, it seems, the registry office). Moreover such cards are usually in good condition. Rarely posted without an envelope most have been kept neatly inserted, away from the light, in family albums; some for over a hundred years.

Outwardly the wedding changed little in those first decades, and, since it was a no expense spared occasion, even the class divide does not show too obviously. Once the ceremony was over, however, it announced itself in the group photographs, so often taken in small gardens or in the case of a cramped backyard (63) no garden at all. The photographer's studio nonetheless offered its backdrops of manorial splendour for more formal gatherings. Some smarter operators indeed provided churchlike sets (144 & 145) as well as domestic illusions more spacious than those to which the young marrieds actually returned. Neither did regulation dress vary overmuch. The bride's outfit had, despite various fashion nuances (and the occasional drastic shift of hemline 115) a timeless quality with its veils and trimmings. The standard dress of the male, however, became even more fixed in the aspic of tradition and a groom in 1953 might wear an outfit appreciably the same as one in 1900. He may even still be carrying that mysterious accessory, gloves never worn.

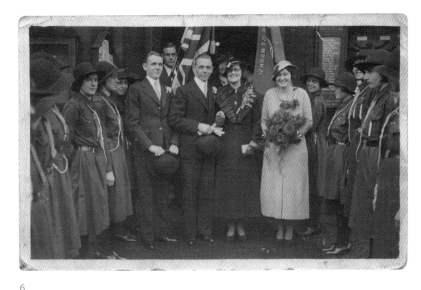

6

Many a bridegroom of humble background became, through the hiring services of the likes of Moss Bros. (as once in my own case) a toff for the day. An alibi for avoiding this pretence occurs in time of war when uniform becomes completely acceptable and the rumpled squaddy in his battledress can stand beside his elaborately gowned future wife and more than make up in pride what he might lack in glamour. Weddings throughout this period (unlike their often gaudy equivalent in the mid 19th century) were not colourful occasions, having it seems adapted like chameleons to black and white photography.

There are relatively few pictures of brides on their own, possibly because of the ill luck that could attend the couple if the man were to catch a glimpse of the wedding dress before the ceremony. I have yet to find an unequivocal solo appearance of a groom, though groups of bridesmaids frequently turn up, with pages or the best man, or just to show off their unified ensembles which can be frightening when taken to extremes as in the starkly contrasted muffs and dresses of 137. As can be seen on tinted photographs brides were allowed some colour (though tinting cannot always be trusted).

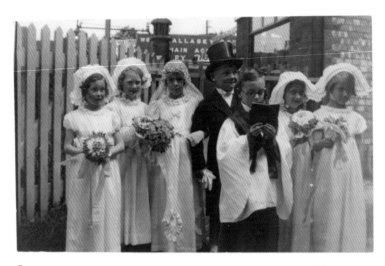

7

In terms of action the key moment is the exit of the newlyweds, pausing momentarily on the steps in a shower of confetti or, more dramatically, emerging through a hastily formed arch relating to the couple's social or professional life; swords for the military, bats for the cricketer's team-mates, rackets for members of the local tennis club or, in the case of cyclists (see *Bicycles* 129), wheels held high. Some of them have an almost surrealistic look as with the lifted crutches of a fellow war invalid (123), the rattles wielded by supportive air raid wardens (124) or the miniature locomotive suspended aloft from walking sticks by railway colleagues (129).

Though ranks of scouts may raise their staves, and files of uniformed girls salute at weddings of Akelas and Brown Owls nothing can quite match in warmth or solidarity the entire troupe of cubs and brownies surrounding the lovely suburban bride in 41.

Not surprisingly it is often the onlookers that generate more atmosphere than the sometimes awkward protagonists. We seem to see the same faces as this crowd of extras moves through time to take up positions by gate or railings, and recognise the same expressions on the faces of women and children. The former forget their own lives

in identifying with new minted promise of joy while the latter see, in the sudden poetic finery, that special moment come to life that so neatly ends all fairy tales.

Thereafter, and beyond the spell of the fairy tale, come those groupings of relatives and friends in which other key figures like the mother of the bride have their moment, or the clergyman that officiated. Each group is bound to have a significance now forever lost as to who was eased in or left out of any secondary gathering. That customary photograph of the whole assembly might itself take the shape of a celebratory truce, for it is not only the aisle that separates his and hers. The essential ikon remains, however, that of the couple itself, even if the image only pretends to be that of the wedding day (see 202 note). A less formal version, hastily produced, can reveal a groom no longer able to postpone the much looked forward to post-ceremonial smoke (52, 53).

The theatrical aspect of a wedding prevails eternally, echoed in children's play acting with bride in high heels eight sizes too large. Some mock child weddings could be more contrived with serious parental input of time and money resplendently in evidence (188). One miniature bridegroom (7) is decidedly pleased with both the event and his performance.

Some years ago, however, I chanced on a card which I thought was similarly a fancy dress picture. Perhaps I even guessed at a lesbian fantasy of same-sex marriage, for whose reality the couple would have to wait another hundred years since both bride and groom were obviously women. Cross-dressing is relatively common in vintage postcards, though usually accompanied by a nudge and a wink. But one by one I found more such images, largely from the Bradford area (190 to 193) in places like Batley, Ovenden and Howden Clough (with one from Merseyside). Always serious, these range from a single pair of bride and groom to an assembly of more than twenty couples. Apart from a doggerel verse which hints at a grand affair called The Olde Village Wedding which took place one Saturday night and a clue, via the ever indispensable *Picture Postcard Monthly*, that this was an annually held charity ball, I have little information. Those not pictured here are now filed under 'Enigma' and left to their solemn fun.

With the exception of such anomalies the question that lurks behind these cards is the eternal 'What then?' One cannot resist guessing how this or that marriage turned out, albeit in the knowledge that such predictions would not be likely to match appearances. This ideal couple perhaps foundered on the rocks of false expectation

whereas that pair, seemingly ill-matched, enjoyed great comfort from each other in a lasting union. We never catch even a glimpse, at least not identifiably, of a honeymoon unless it be for the splendidly choreographed group on the boarding house steps who may have built the honeymoon in their marriage arrangements (201, see note).

The thousands of cards which show burgeoning families, some fraught but many sound and content, give cause for optimism, not to speak of the many images of Darby and Joan who married when Queen Victoria was young and still, well into the 20th century, were robustly companionable.

One wishes them all of that luck which swinging horseshoe, black cat, the borrowed and the blue should have helped to guarantee. I for one take special heart from the occasional glimpse of the exchanged (33) or outwardly evident expression of radiant love. Like the marvelling child one hopes to see from these many beginnings the proper fairy tale sequel of a happy ever after.

Note

All the cards are real photos taken directly from glass or film negatives. Though reduced to 75% of actual size , they are shown as found with only the occasional adjustment of border, contrast, or the removal of a distracting blemish. The captions give the date (where known) and the name (if provided) of the photographer or studio. An occasional attribution to 'Jerome' or 'USA Studios' for example is to a nationwide chain of studios or processors with no particular location. An asterisk indicates that further information is provided in the notes. A general commentary on the history and essence of the photo postcard can be found on p110.

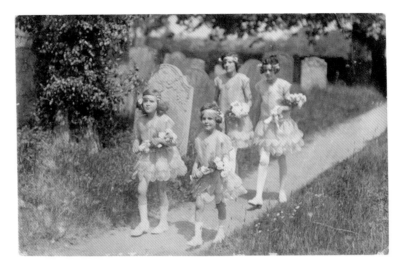

8　E. Whitney, St. Ives

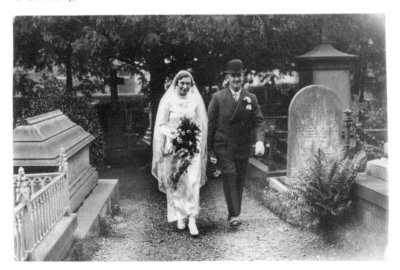

9　Frank Bailey, Canterbury

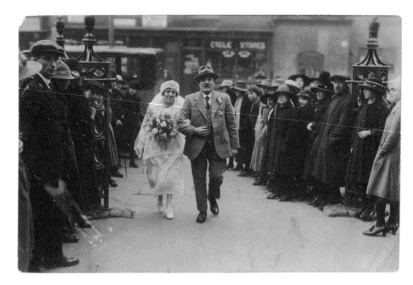

10

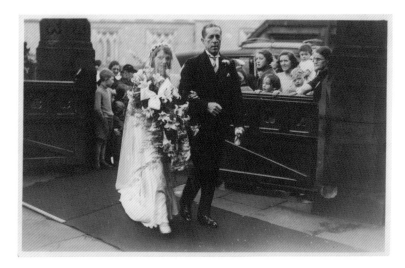

11 Walkers Studios, Scarborough

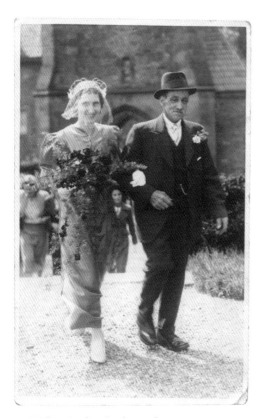

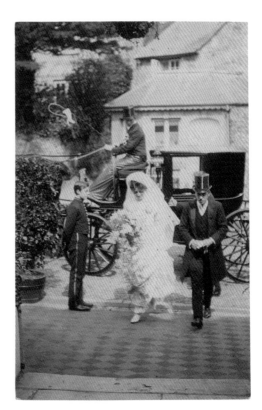

12 Walkers Studios, Scarborough

13 Shanklin, I. W.

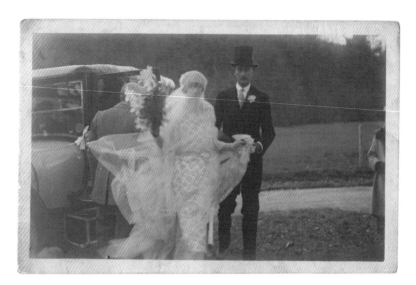

14

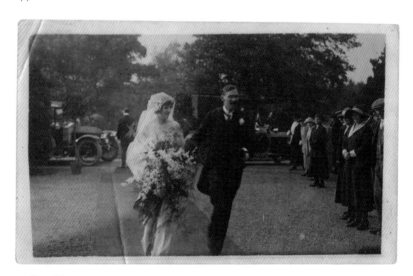

15 Teesdale

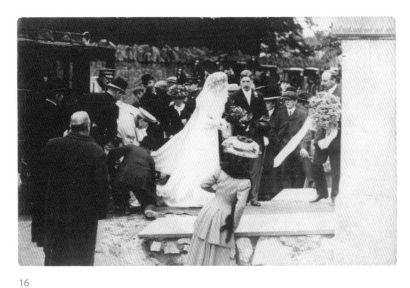

16

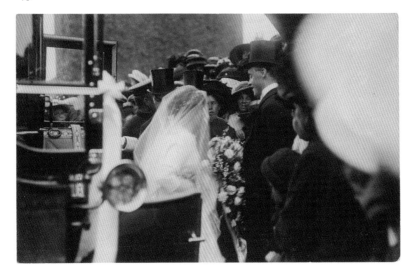

17 Norfolk

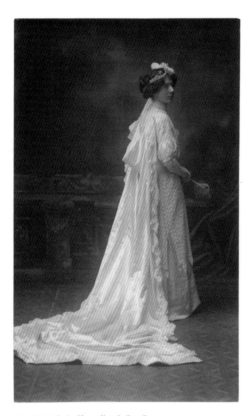

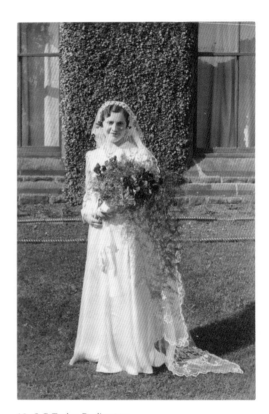

18 1913, S. A. Chandler & Co., Exeter

19 S. E. Taylor, Darlington

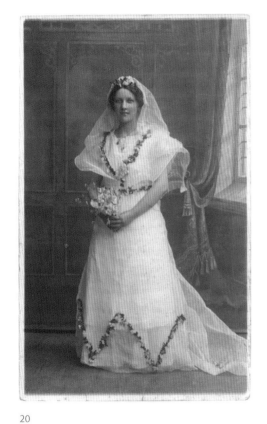

20

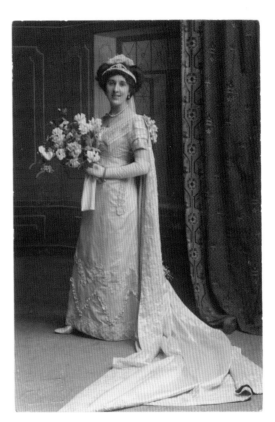

21 Tate, Elmside, Exeter

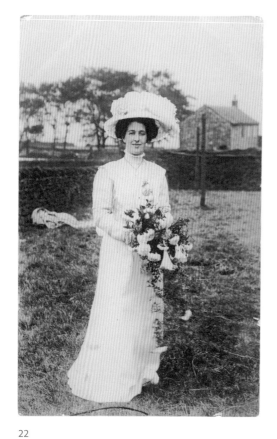

22

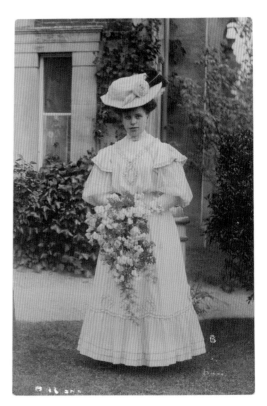

23 H. Loomley, Stroud

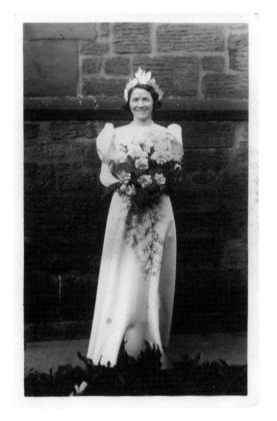

24

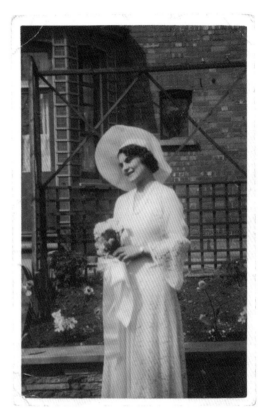

25

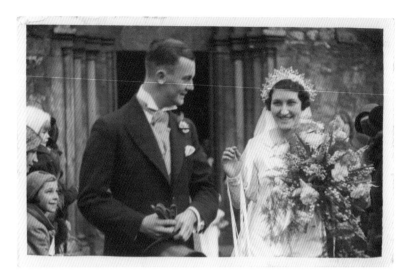

26 Spencer's Press, Grimsby

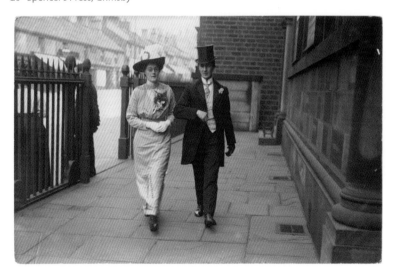

27

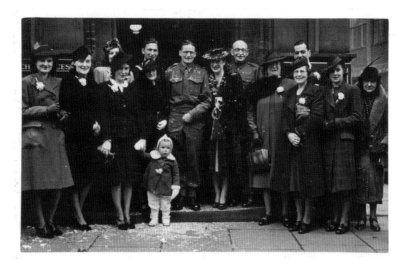

28

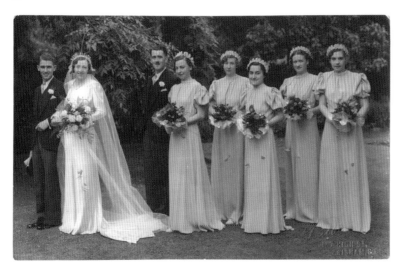

29 Dalby, Lewisham

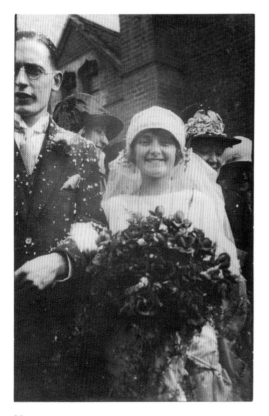

30

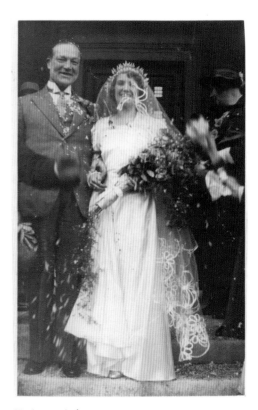

31 Jerome Ltd.

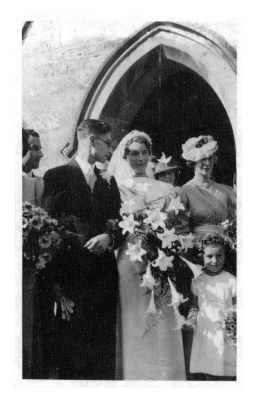

32 1939

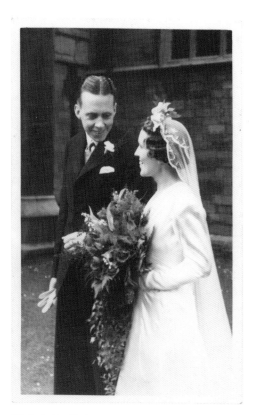

33 Yorkshire Post

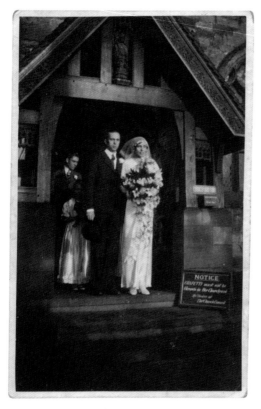

34

*

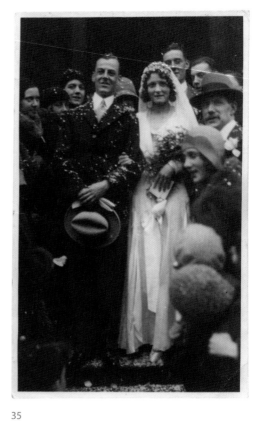

35

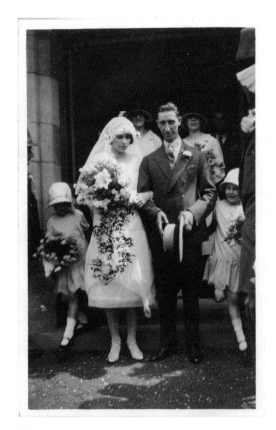

36

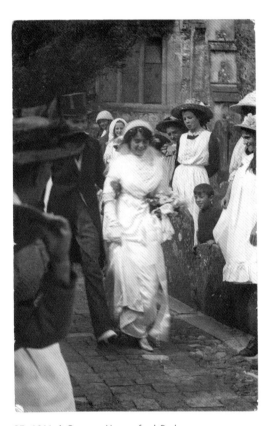

37 1911, A. Parsons, Hungerford, Berks.

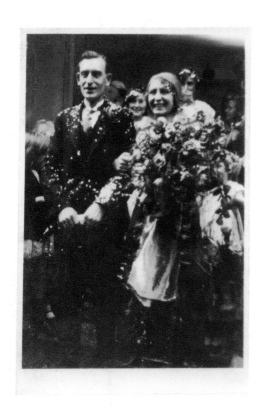

38

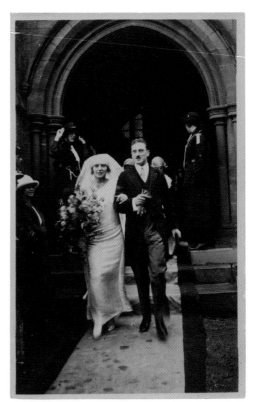

39

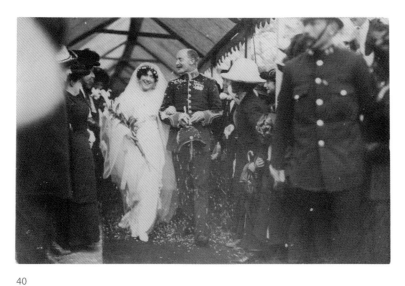

40

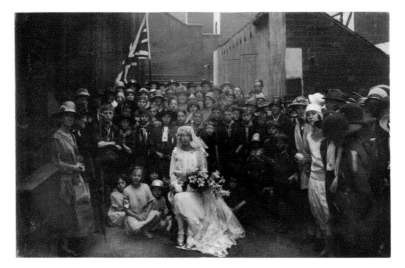

41 L. D. Swift, Sheffield *

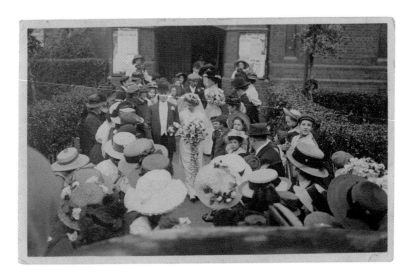

42

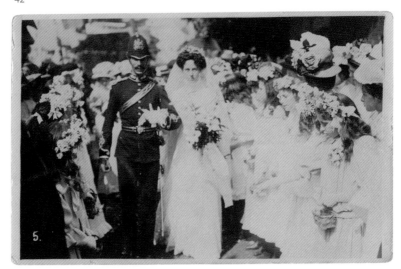

43 B. & W. Fisk-Moore, Canterbury

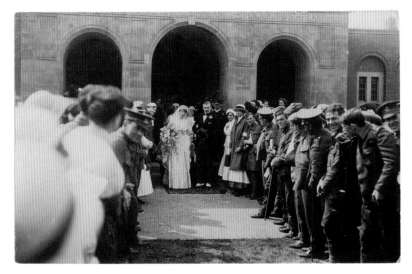

44

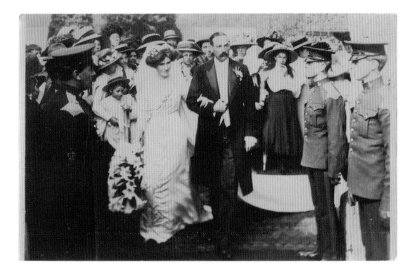

45

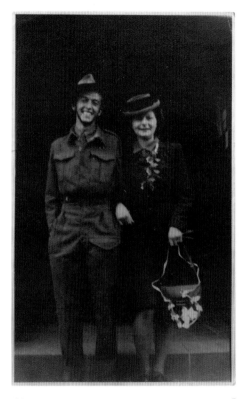

46 *

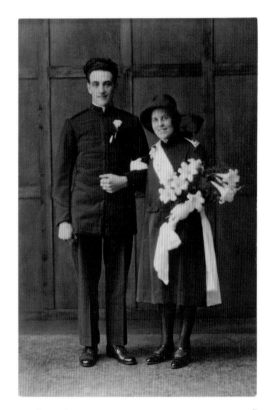

47 Soton, Hants *

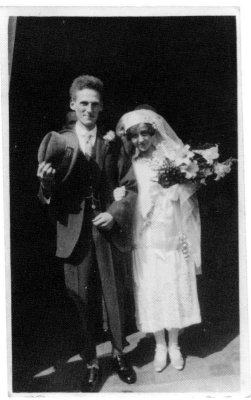

48 Thomas & Jacobson, Wallasey

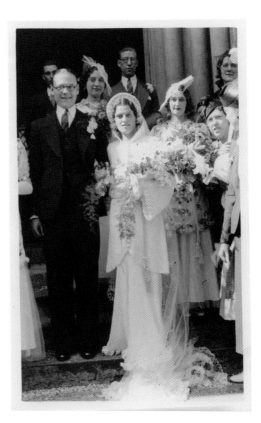

49

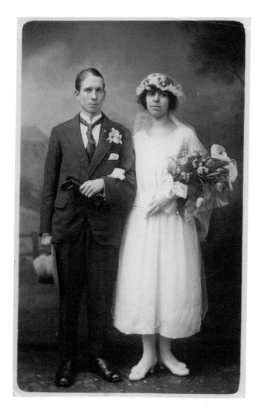

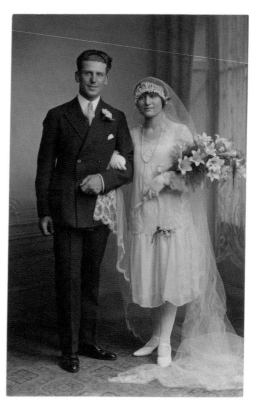

50 1923, Alfred Juggins, Birmingham * 51 Ed Sharp, Westminster Bridge Rd, S.E.

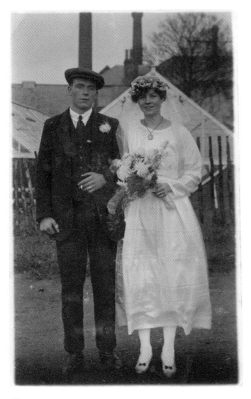

52

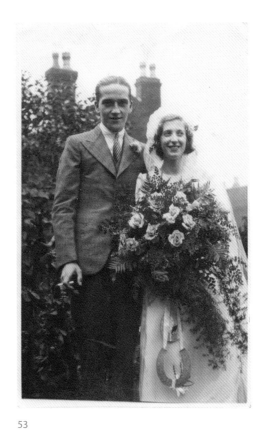

53

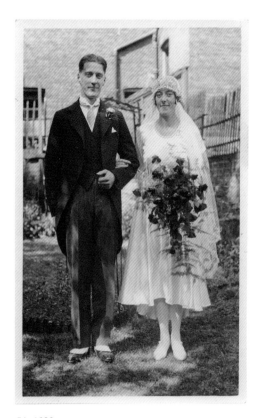

54 1929

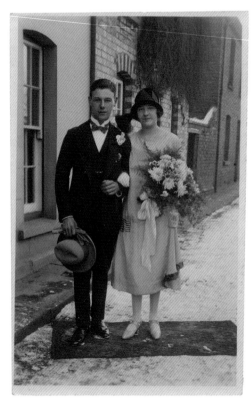

55 O. Jackson, Brecon

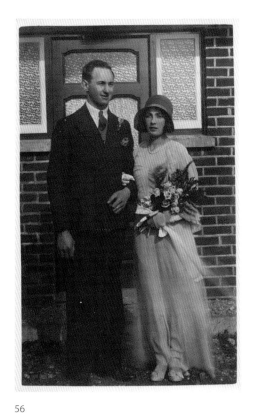

56

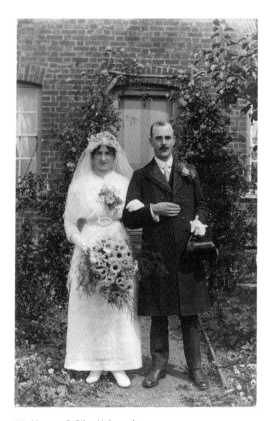

57 Horace G. Pike, Halstead

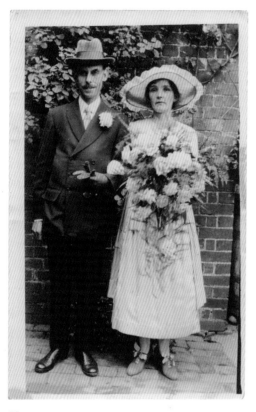

58

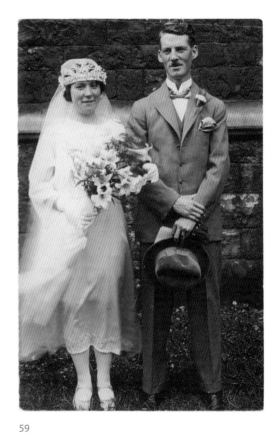

59

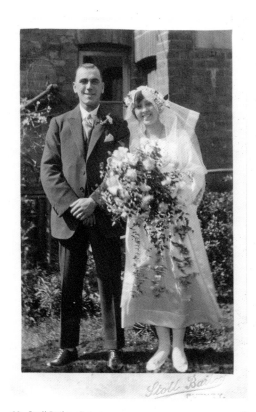

60 Stoll Bailey, Putney

*

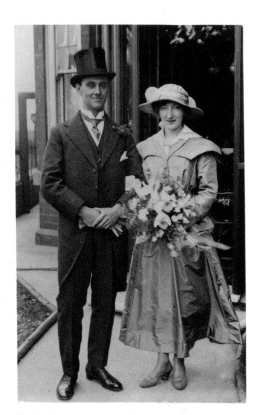

61 J. H. Cleet, South Shields

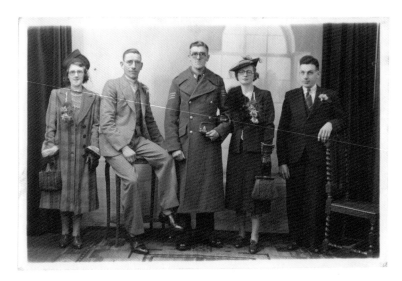

62

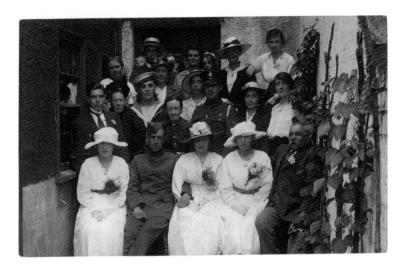

63

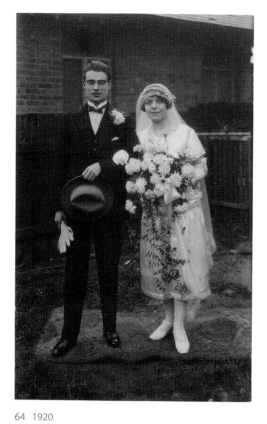

64 1920

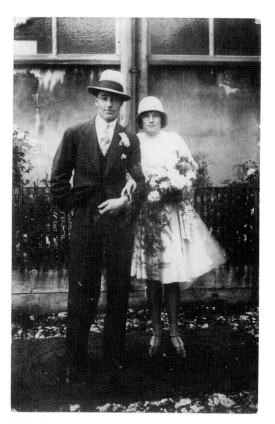

65 Bridlington

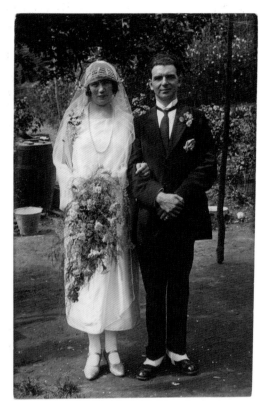

66

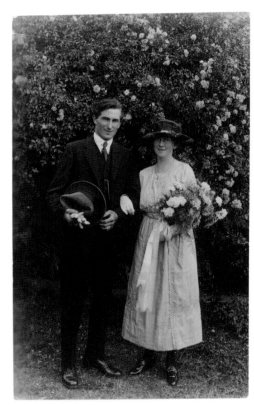

67 Emery Photo, Felixstowe

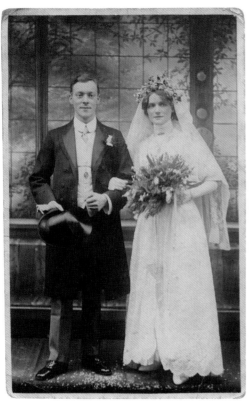

68 Purcell & Betts, North Aston Manor

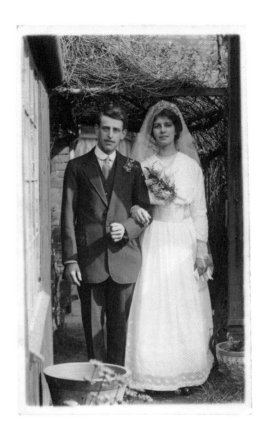

69

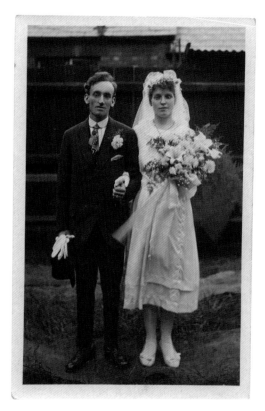

70

*

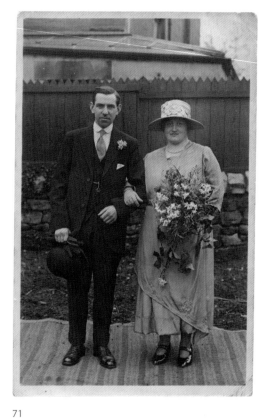

71

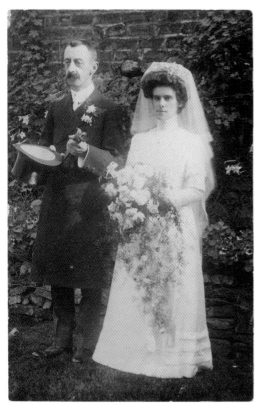

72 Outhwaite

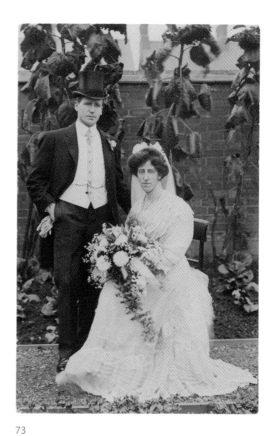

73

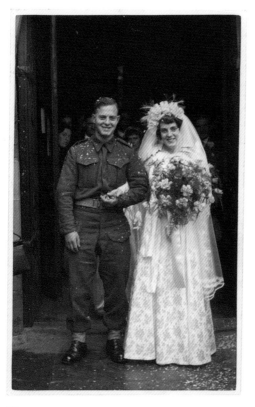

74

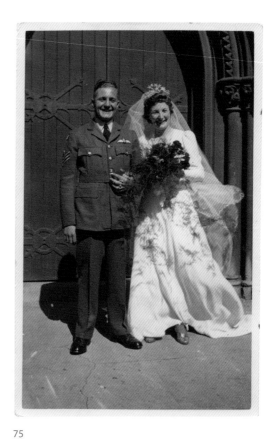

75

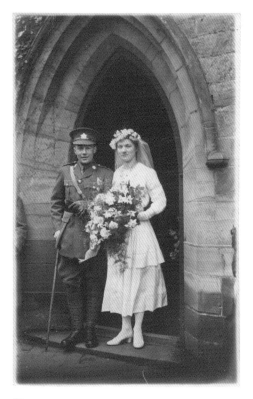

76

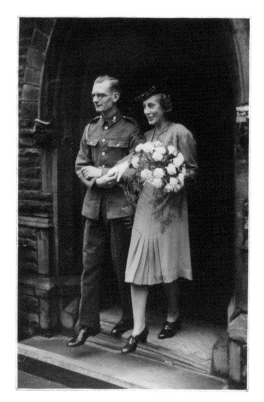

77

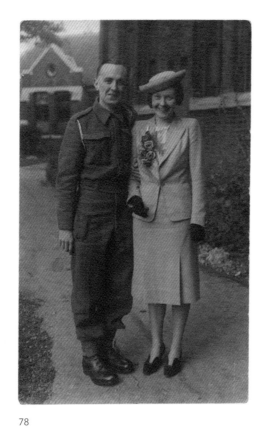

78

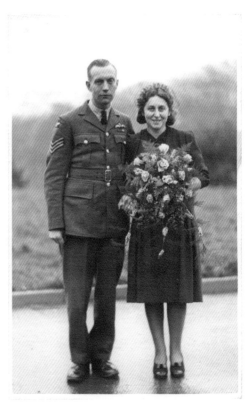

79 Walkers Studios, Scarborough

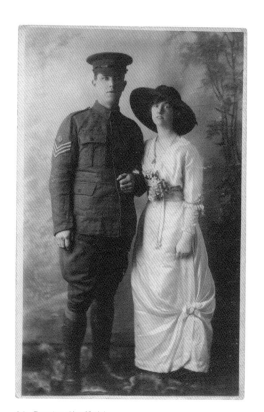

80 Furniss, Sheffield

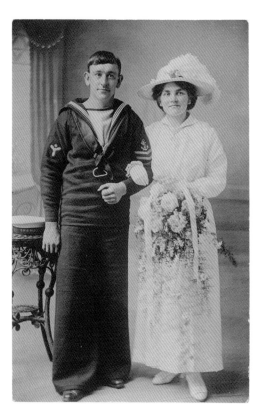

81 Merrett Bros., Stroud

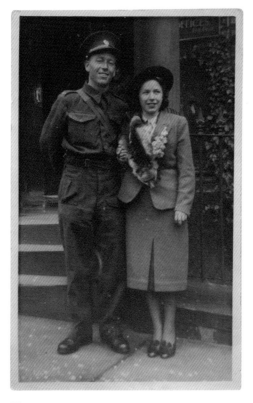

82

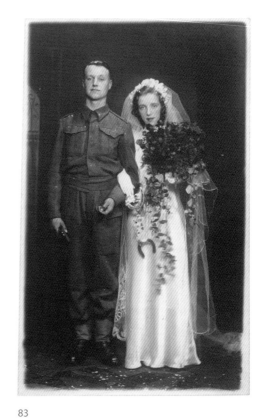

83

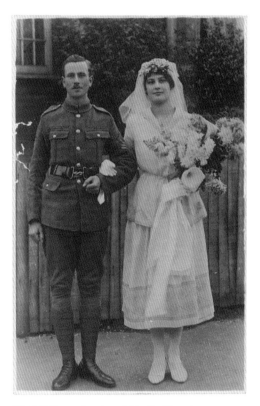

84 G. P. Hoare, Goodman's Studio, Margate

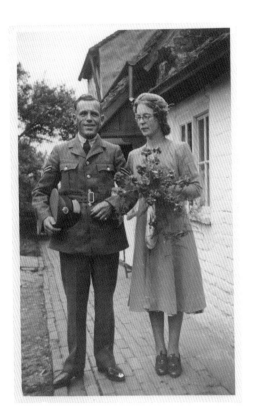

85

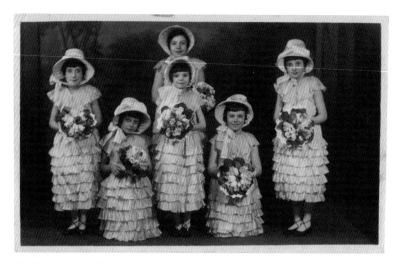

86 Ainley Studios, Ravensthorpe

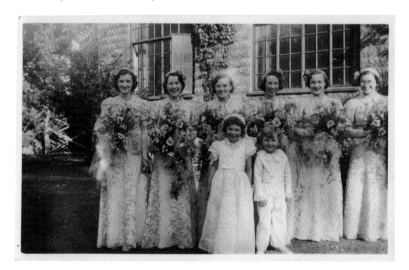

87

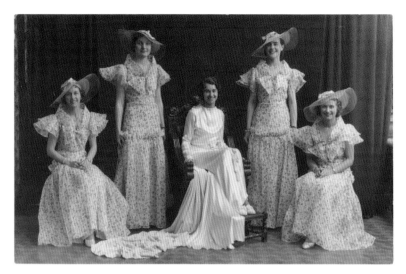

88 Witfield Cosser & Lankesheer, Colchester

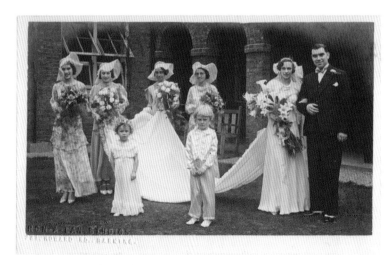

89 Ron-A-Lan Studios, Barking

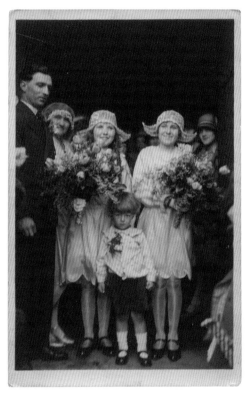

90

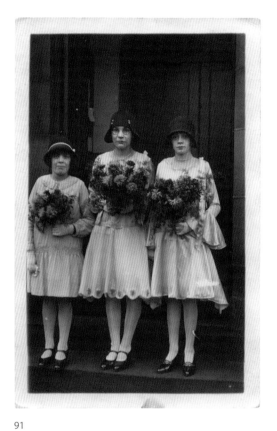

91

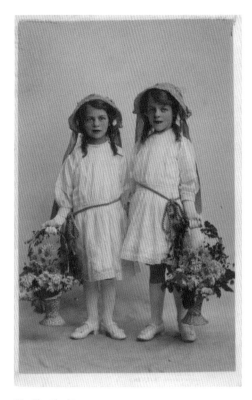

92 Chettle, Nuneaton

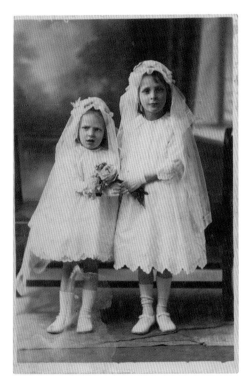

93

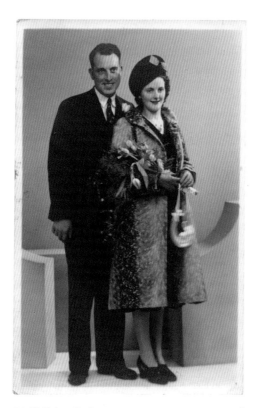

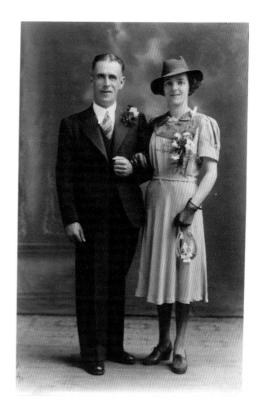

94 W. Risbey, Darlington * 95 A. Harding, Rhyl

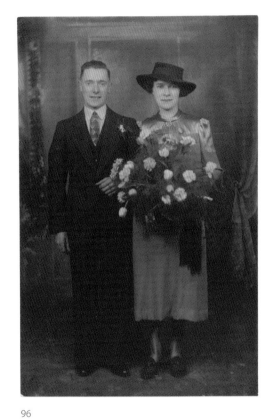

96

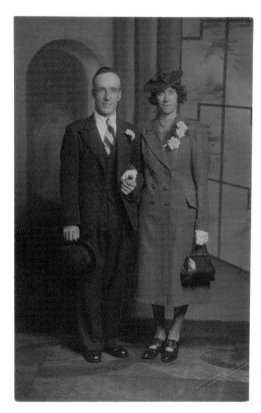

97 Stanley Bros., Leytonstone

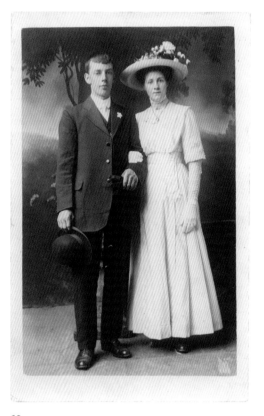

98

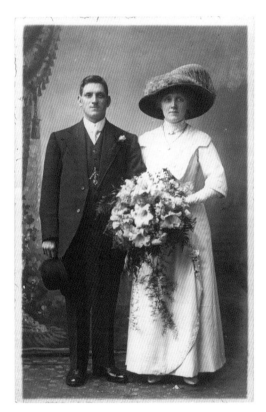

99

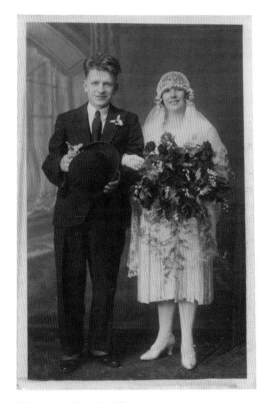

100 J. Asquith, Eccleshill

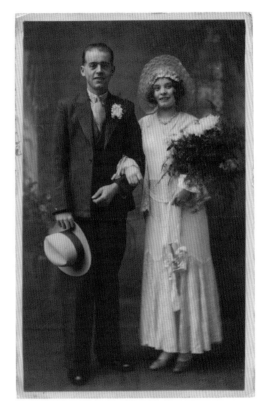

101

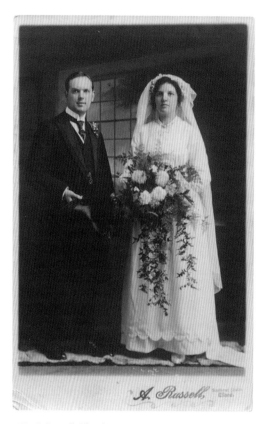

102 A. Russell, Elland

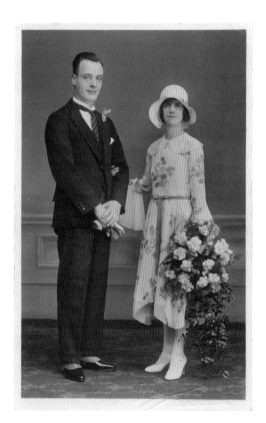

103 Sharples, Blackburn

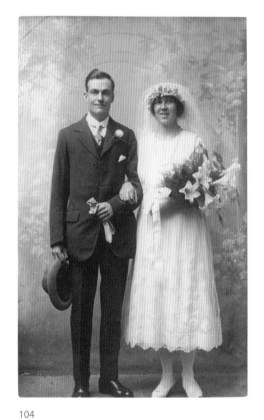

104

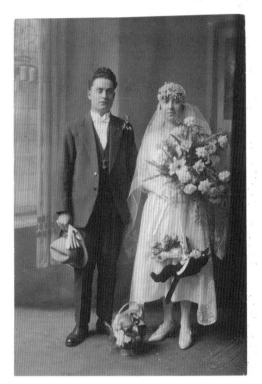

105 Dudgeon, Hinckley Rd.

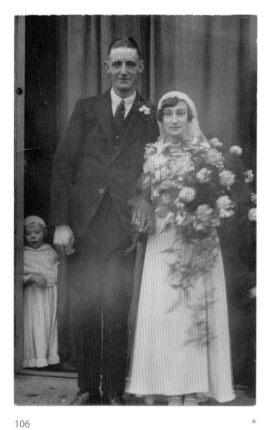

106

*

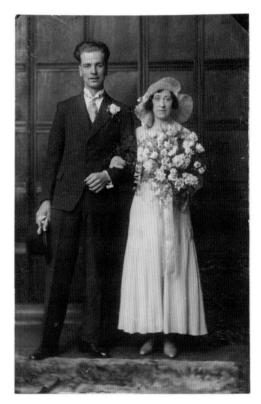

107

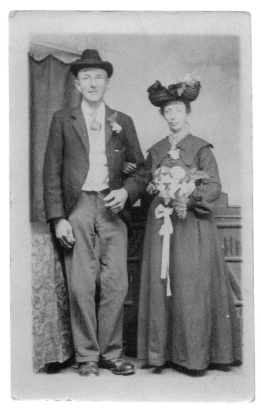

108

*

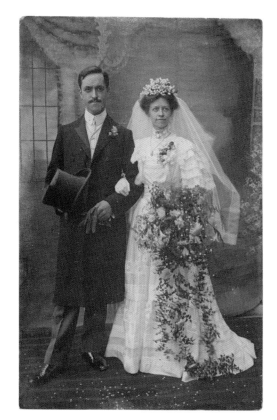

109

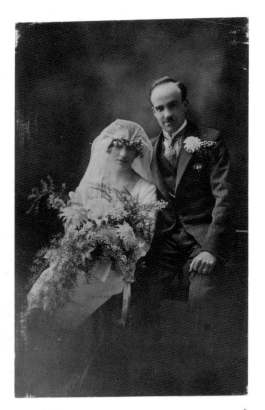

110 1926

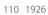

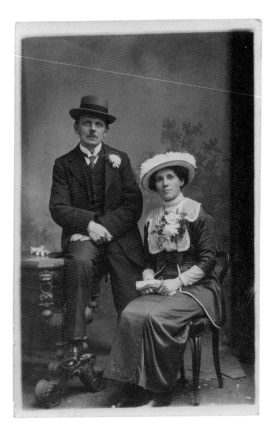

111 T. H. Head, Portsmouth

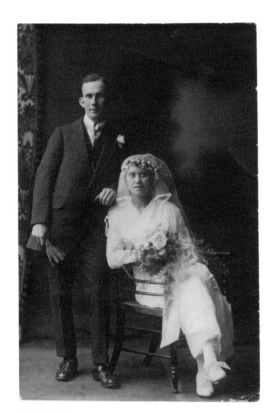

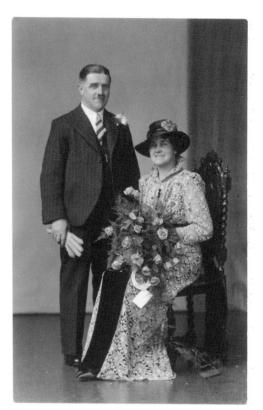

112 1919, Hawick * 113 Harrison, Lincoln

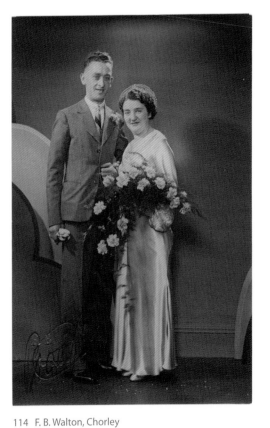

114 F. B. Walton, Chorley

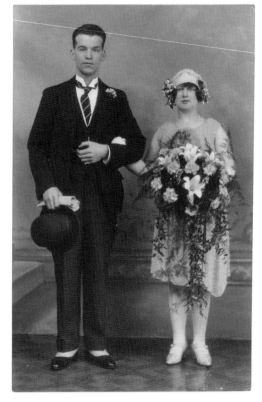

115

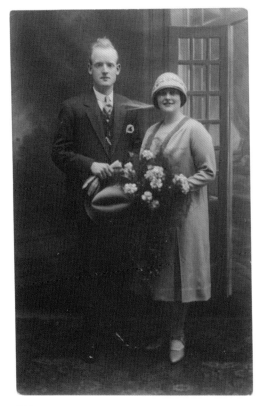

116

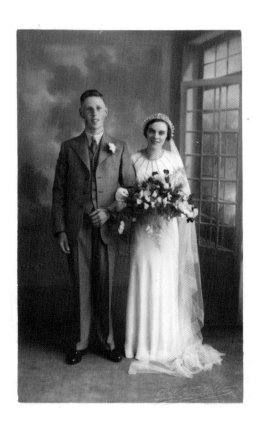

117 A. H. Stickells, Tunbridge Wells

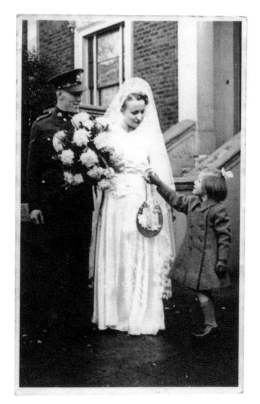

118

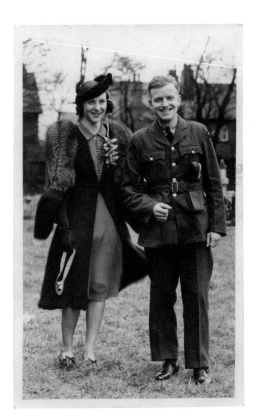

119 Yorkshire Post *

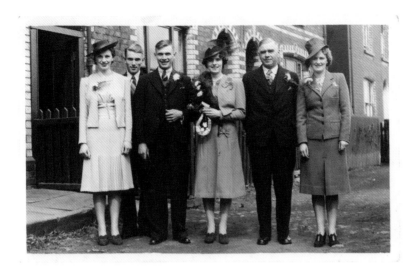

120 L. H. Morgan, Abersychan

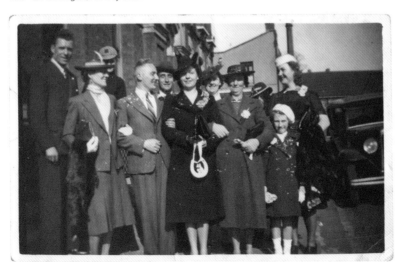

121

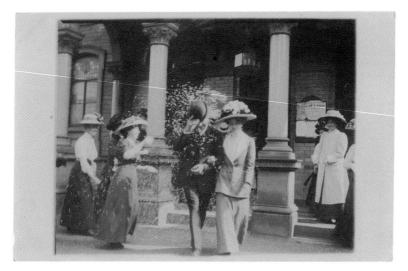

122

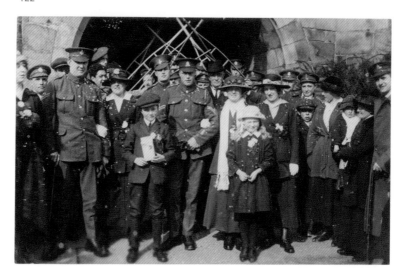

123

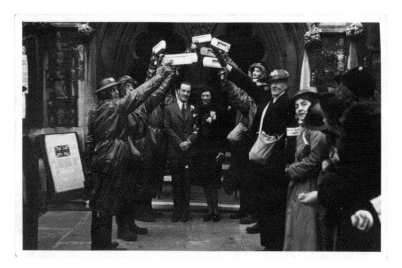

124

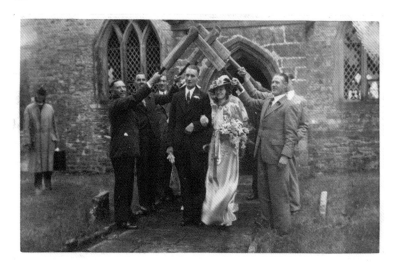

125

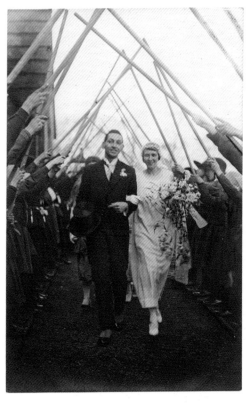

126

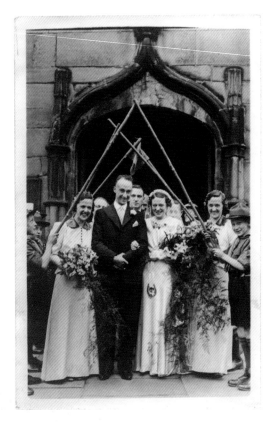

127

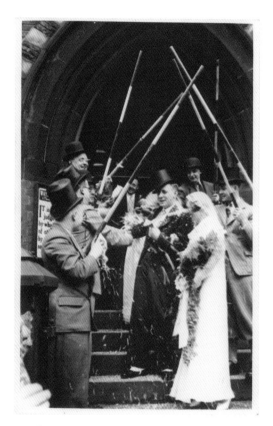

128 Royton, Lancs

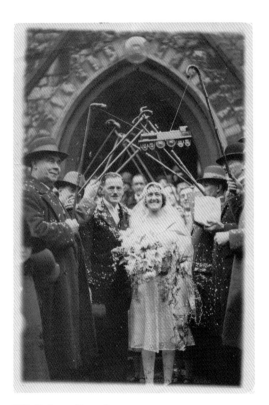

129 Scrivens, Herne Bay

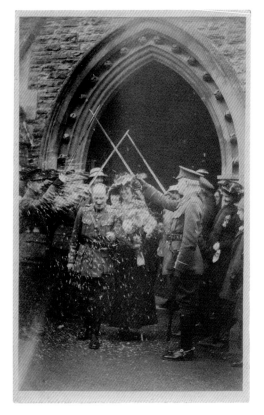

130

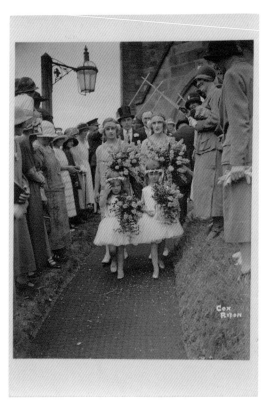

131 Cox, Ripon

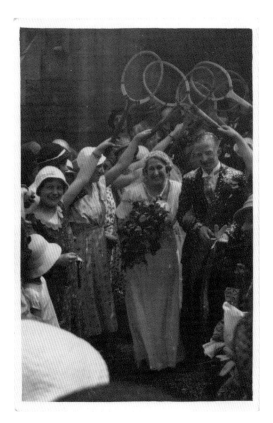

132

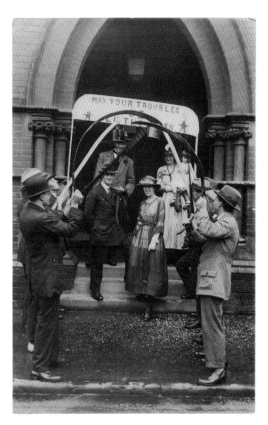

133 1921

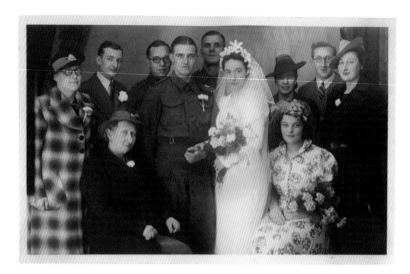

134

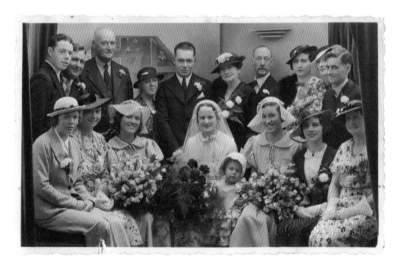

135 Edwards, Southampton

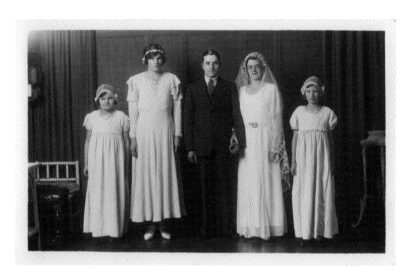

136 Herbert Vieler, Bexhill on Sea

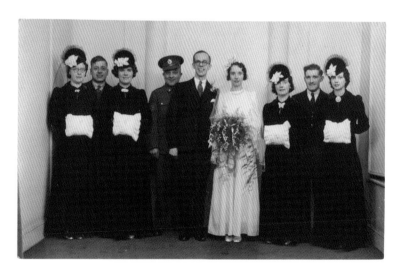

137 George J. Leech, Denton

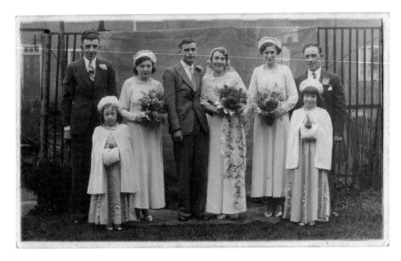

138

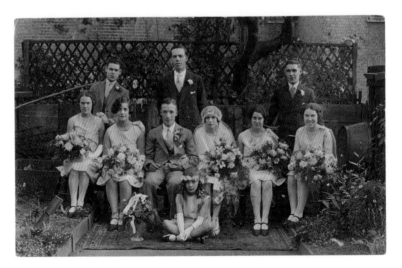

139

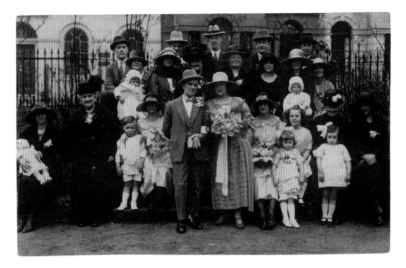

140

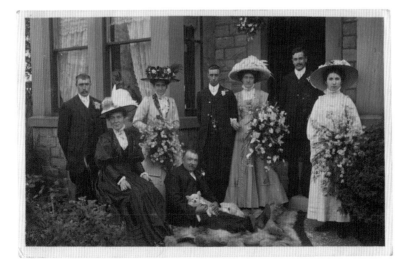

141 1910, Lancaster

*

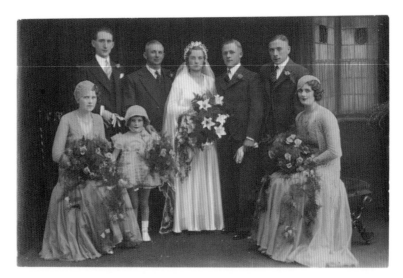

142 Henry Melling, Preston

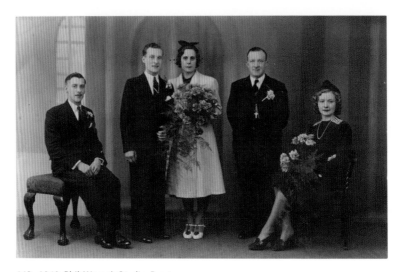

143 1940, Phil. Warne's Studio, Preston

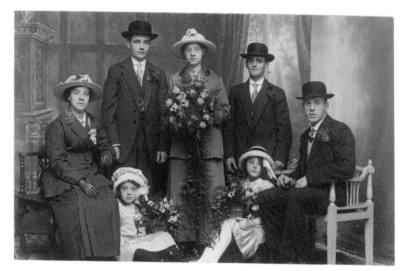

144

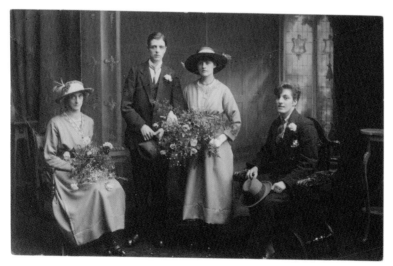

145 Henry Melling, Preston

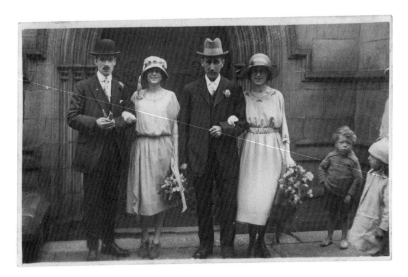

146

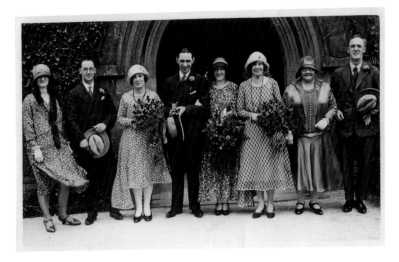

147 Lytham St. Annes

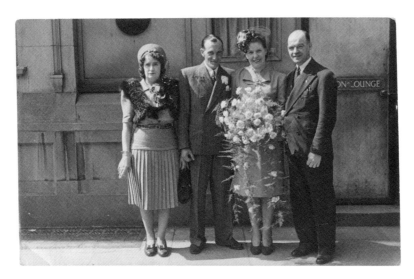

148 P. McEntire, Camden Town

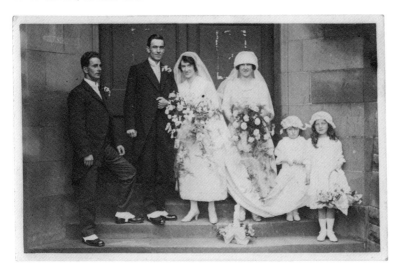

149

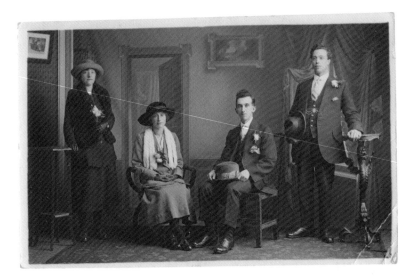

150

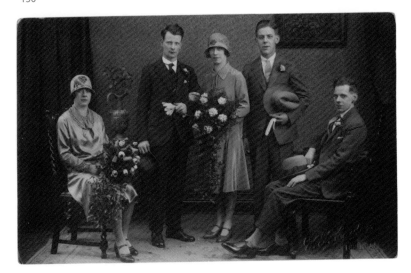

151 W. T. Carter, Rochdale

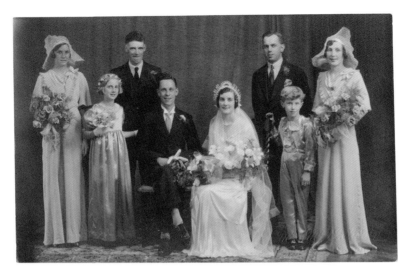

152 G. Swain, Norwich

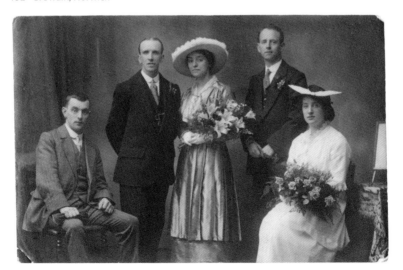

153 F. Proctor, Bolton *

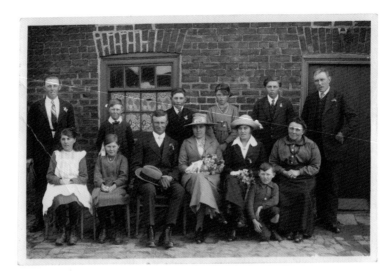

154

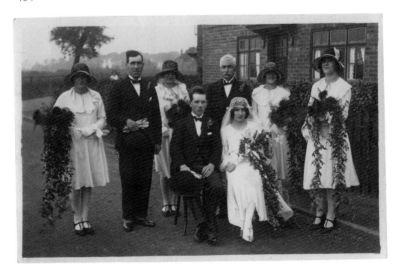

155　Wheeldon, Cadishead

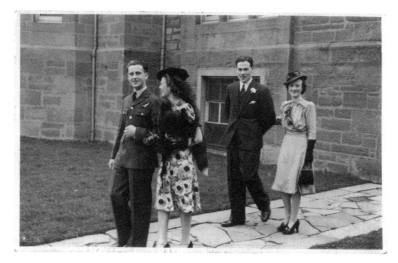

156 *

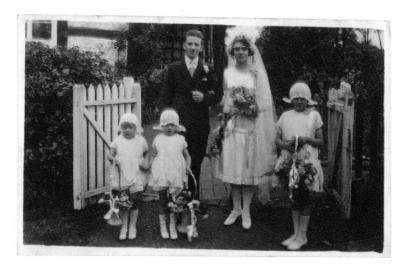

157

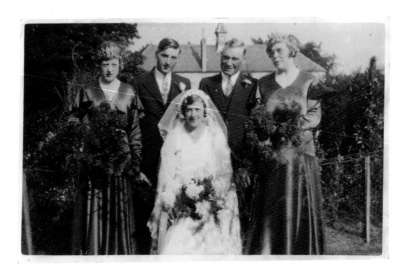

158 Jerome Ltd.

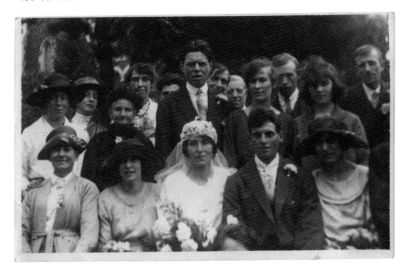

159

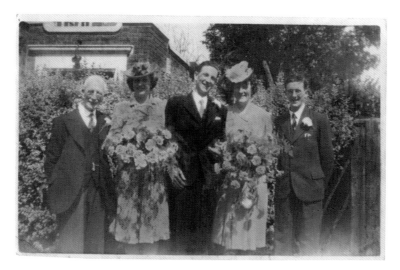

160 1946

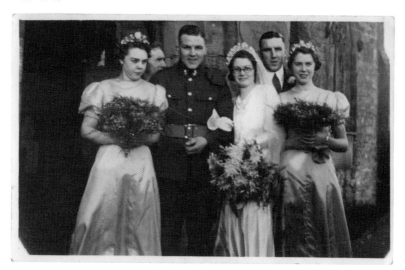

161

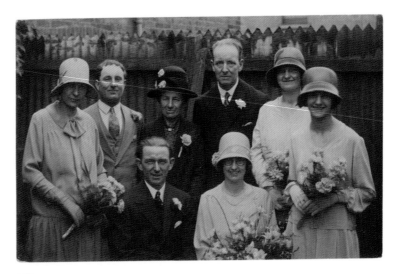

162

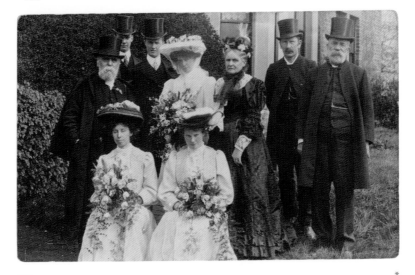

163

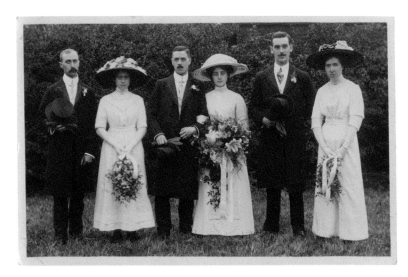

164 A. Sunderland, Savile Town

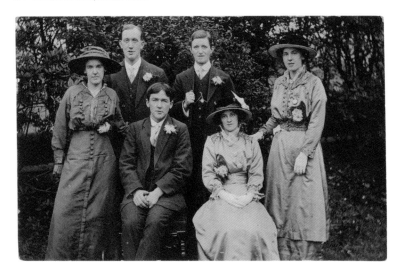

165

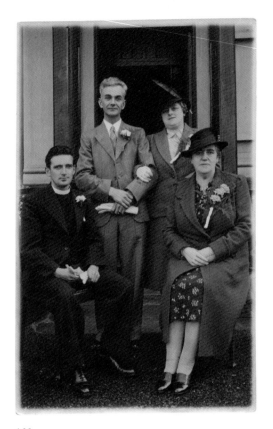

166

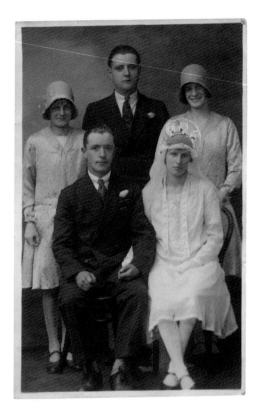

167 Fred C. Palmer, Swindon

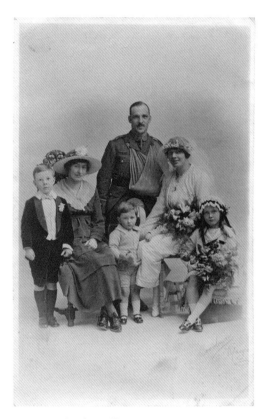

168 1916, Goodman, Margate

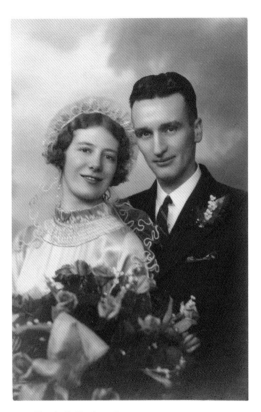

169 Turnbull, Blackpool

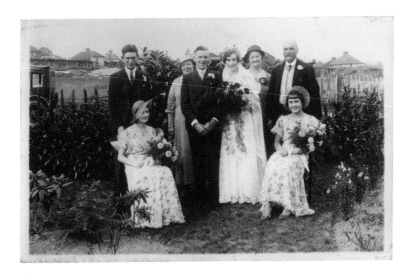

170

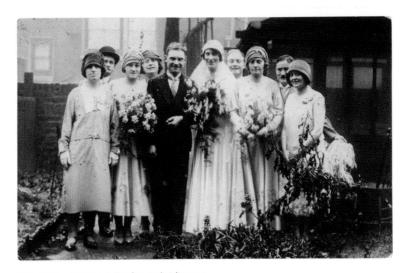

171 William's Pioneer Studios Ltd., Islington

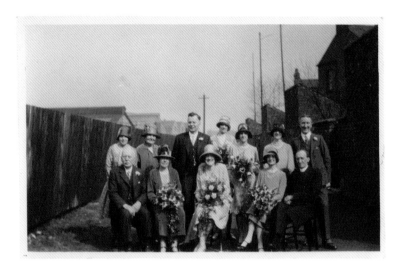

172

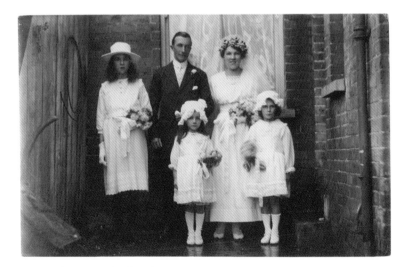

173 Fred Quinton, Isle of Wight

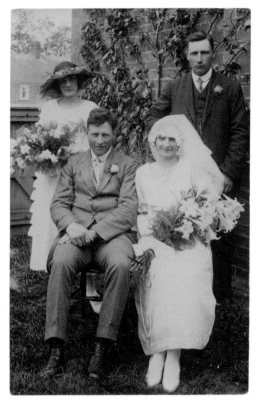

174

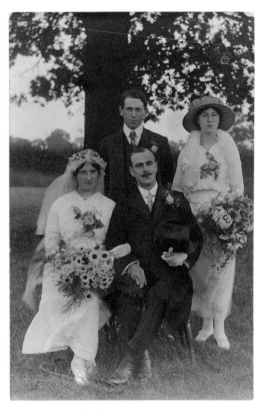

175 Horace G. Pike, Halstead

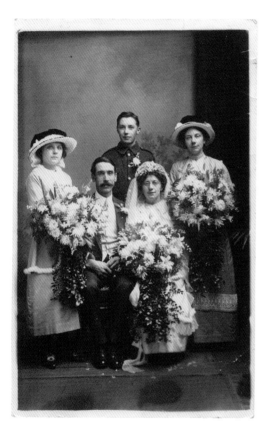

176 T. H. Head, Portsmouth

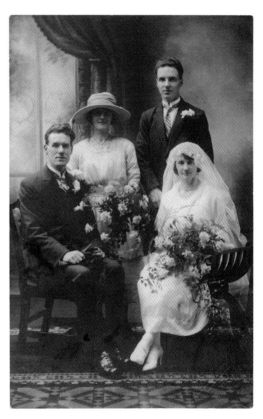

177 J. E. Murray, Hawick

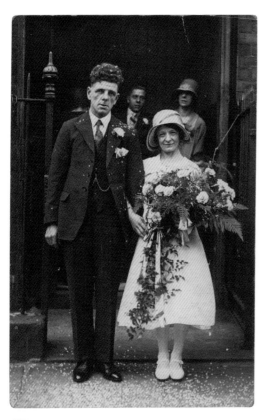

178

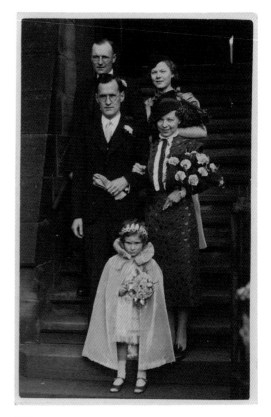

179

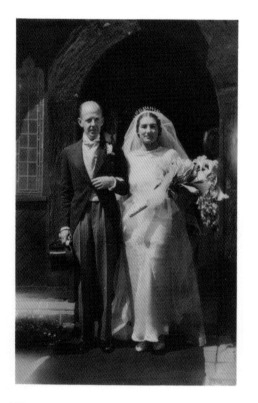

180

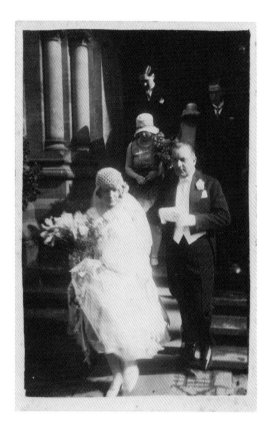

181

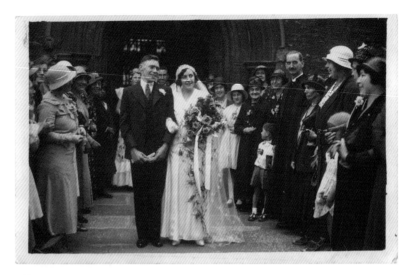

182

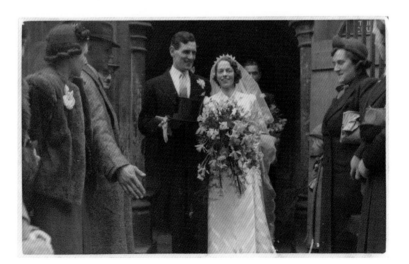

183

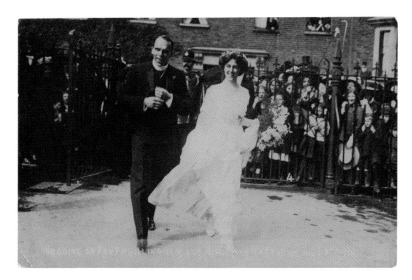

184 1910, Park's Press Photographic Agency Ltd., Fleet St., London E. C. *

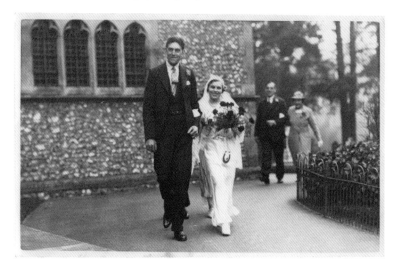

185 Windsor-Spice Ltd., Redhill

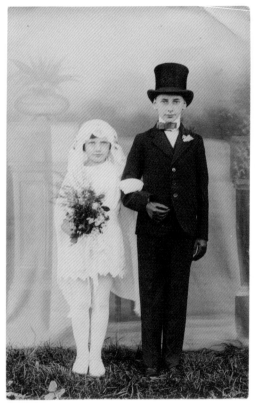

186

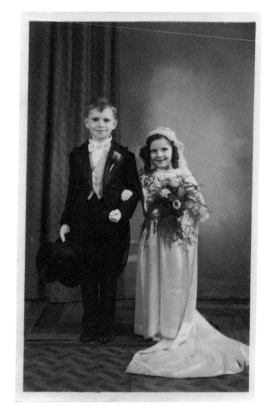

187

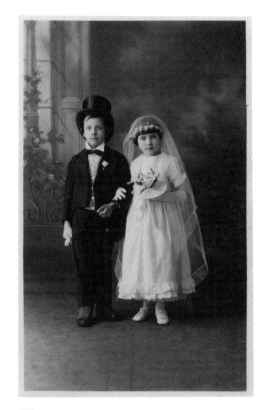

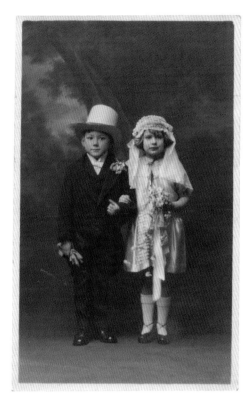

188

189 Robt. H. Rice, Eastbourne

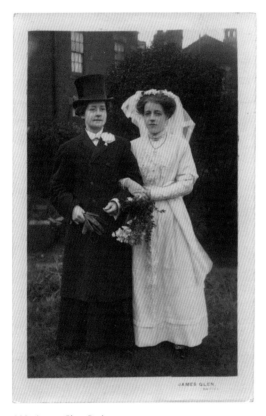

190 James Glen, Batley

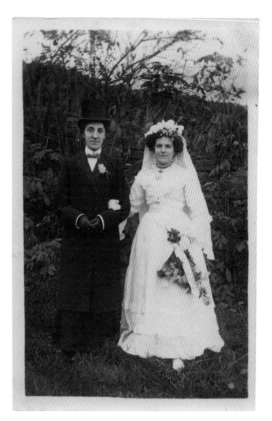

191

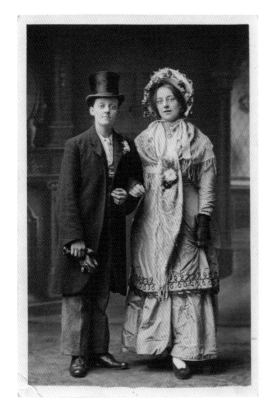

192

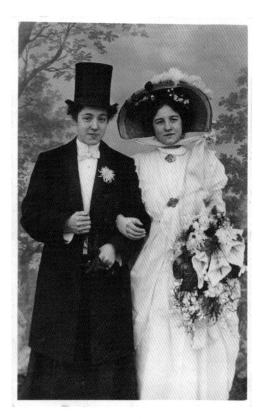

193 Woodcock, Wibsey, Bradford

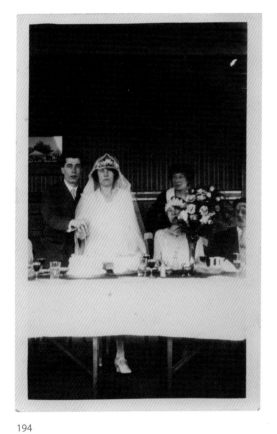

194

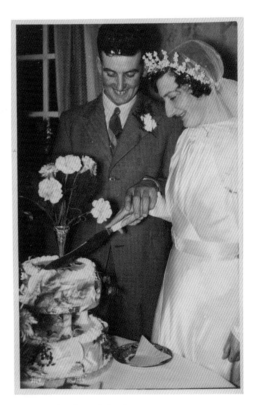

195 Frank J. Sage, Bristol

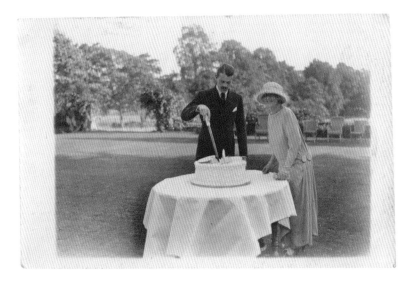

196

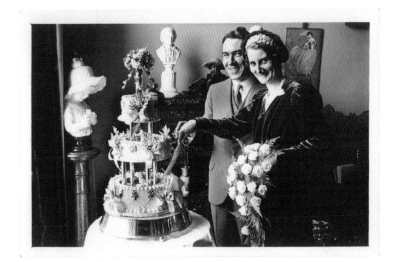

197

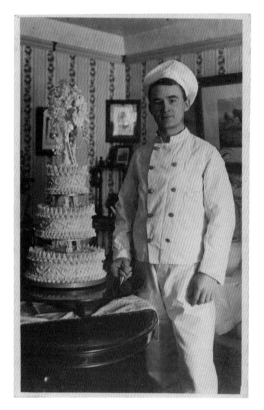

198

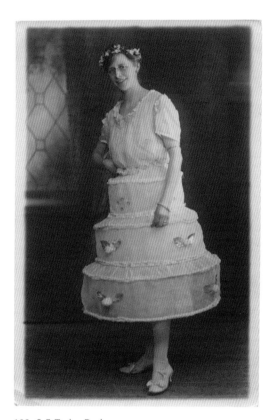

199 S. E. Taylor, Durham

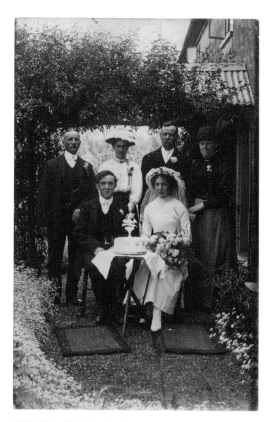

200 Clarke, The Studio, Bungay

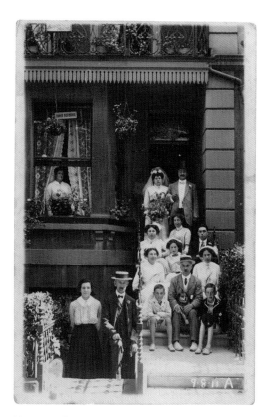

201 1911, Geo. Austin, Eastbourne *

GENERAL COMMENTS AND NOTES

To have a portrait made and to possess your own likeness was, for centuries, a luxury that only landed gentry or the mercantile rich could afford. Photography changed all that. Yet a radical democratisation of portraiture had to wait until 1902 when the post office finally allowed messages as well as addresses to appear on the backs of the regulation-sized cards that cost only a halfpenny to post.

You could now go to one of the studios springing up all over the country, pose for your picture, examine the result after a short interval and, approving it, have it replicated for not much more than a penny a card. A supplementary service was offered (at a price) in the form of hand tinting. It seems that statistically Penny Plain was much preferred to Tuppence Coloured.

You might choose, instead of being seen against a neutral background, to be transported via the studio's selection of theatrical backdrops and plaster props to a dwelling of baronial splendour; or to some rural idyll with a view of lake or sea. While factual in appearance the end product (like the painted portrait it evoked) was a servant of dreams. Specialised city studios offered even bolder scenic fantasy, providing costumes and accessories to match. There you, your family and friends could become a troupe of Pierrots, or mimic the Cowboys & Indians of the cinema screen.

A studio's more prosaic outreach included visits to school, office and factory. The local photographer, working street by street, could show you outside your house or shop, or in the privacy of your garden. At church or on the beach he was the inevitable imagist of your wedding or holiday. In effect you could hardly escape him, even by excursion, since no boat trip or charabanc outing was complete without its group photo.

The repertoire was further extended by enthusiastic amateurs: few social gatherings or sporting events were without one ready to record a picnic or winning team. The genre as a whole was in turn radically augmented by the mass produced camera, whose Model T Ford was the Box Brownie. Any local chemist would now be ready to turn your negatives into photo postcards. The snapshot aesthetic introduced a true pictorial vernacular and freed the photograph from imitation of art.

Early in the century the hobby of collecting commercial picture postcards was already well established. Every household boasted an album full of views of places visited, celebrities admired etc. The private photo postcard soon enriched it with an archive of rather more familiar faces. Exchange of such cards became a social ritual. To this we owe the good condition of so many, since they were more often sent in envelopes than posted directly.

So active before, during and after the First World War, the fashion barely survived the Second with its restrictions and austerities. In the late forties only the beach photographer re-emerged. I was last snapped with my parents on a windswept walkway of the Festival of Britain in 1951. My father (who had first been a postcard subject in 1906) failed to buy the result. It seemed to mark the end of the affair.

Photographic portraiture has come full circle: a formal studio portrait is once more a luxury item. Now that our phone, or even toothbrush, can record a more than passable image we are refracted in a kaleidoscope of likenesses.

Many of the largely anonymous people presented here are seen across more than a century, yet it would be wrong merely to view them through the patronising lens of nostalgia. On the contrary they assert and reveal their proper modernity by deportment, style and fashion. Each of their identifiable vintages is the expression, not of a Then, but of a Now that has gone.

N.B. Readers, and especially proofreaders, beware...
As in the texts of ancient civilisations most everyday
writers of this period used punctuation sparsely if at all.
My mother (born 1901) never got the habit, though
if she were writing formally, she would sometimes, as
from a pepper mill, scatter a few random dots about.

5 Ernest J. Pedley, Press Photographer, 13, West Road,
Congleton

34 NOTICE
CONFETTI must not be thrown in the Churchyard
By Order of The Church Council

41 *Miss Myrtle Robinson*
142 Burngreave Rd
Married at Holy trinity
Nursery St.
to Frank Yates
Father John Robinson
Iron Founder

46 *Dennis Bird, Amy End of IInd World War*

47 *To Connie from Harry & Maud* [Salvationists]

50 *To Floss & Ernest with love from Gertie & Fred*

60 *Charlie Burrett & Winnie Green*

70 *To Florrie with Mr & Mrs Hobbs compliments*

72 *George & Ciss*

94 *Mr & Mrs R. Brayshaw*

106 *To Georgeian & Arthur From Dod & Percy*

108 *To Mrs Babyjohns in Newton Abbot, i an sorry i keep you*
so long but waiting for card love to all Milly this is Mr Mrs
Butland

110 *With best wishes May & Len*

112 *Mr & Mrs R Crawford*

119 *John Trevor Park & wife just married 194... (wife's name to*
find) Marjorie

124 Armband reads 'Post Warden Lambeth'

141 To Miss Bastow in Bradford, *just to let you know that I have*
not forgot you. Maggie

153 *William Laidlaw*
Harry Hindle married May Laidlaw
? Jones
? Theresa Jones

156 *This is Ina's wedding group. Mr & Mrs John Douglas Dowson*
also Jessie and best man who is her husband now Mr & Mrs
John Peebles We are always hoping to get word he is safe

163 *J. Kerr's Wedding (of Deepgrove Farm)*

184 *Wedding of Rev. F. H. Gillingham & Miss Mary Matthews*

201 To M. C. Davidge in Hackney. *Dear Charlie We are staying at*
Eastbourne for our Hollidays and having a jolly time weather
very hot but cool on the water went to Brighton yesterday by
boat. Fred

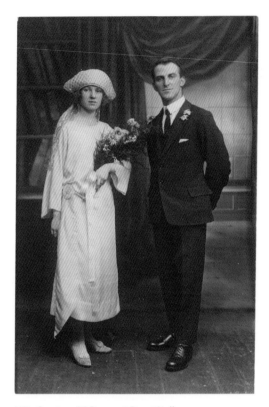

202 Overton, 85 Prospect Street Hull

Dear Auntie Annie. These photos were taken three months after the wedding We like them, but we think they would have been nicer taken at the time as my bouquet is not so pretty, but still they are something to look back upon. We are getting on fine, we just want a house and then we shall be made up. Give my love to all, Billy & I will be pleased to see you sometime. Best love from. Pops